Thank-you so much Dad!

"pg 21" I thank you for "all...
only what we understand & mo...
All- what we have been taught!"
You have taught me to be kind to others
& to love"

Thank-you so-so much for all
you do!

Love You forever and Always

Karen
(Muffy)
xoxox

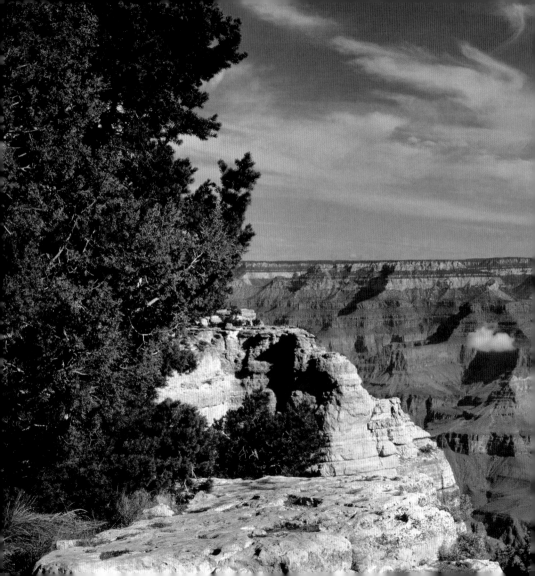

GRAND
CANYON
REFLECTIONS

GRAND CANYON ASSOCIATION

Grand Canyon Association
PO Box 399
Grand Canyon, AZ 86023
(800) 858-2808
www.grandcanyon.org

Printed in China
Compiled by Todd R. Berger and Carolyn Deuschle
Designed by Ponderosa Pine Design, Vicky Vaughn Shea

First Edition
15 14 13 12 11 2 3 4 5

Library of Congress Cataloging–in–Publication Data

Berger, Todd R., 1968–
 Grand Canyon reflections / [compiled by Todd R. Berger and Carolyn
Deuschle]. –– 1st ed.
 p. cm.
 Includes bibliographical references and index.
 ISBN 978-1-934656-12-9 (alk. paper)
1. Grand Canyon (Ariz.)––Pictorial works. 2. Grand Canyon (Ariz.)––
Quotations, maxims, etc. I. Deuschle, Carolyn. II. Title.
F788.B476 2011
979.1'32––dc23

 2011030881

*The mission of the Grand Canyon Association is to help preserve and protect
Grand Canyon National Park by cultivating support through education
and understanding of the park.*

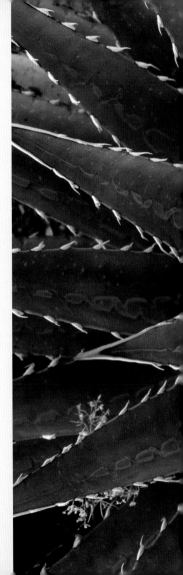

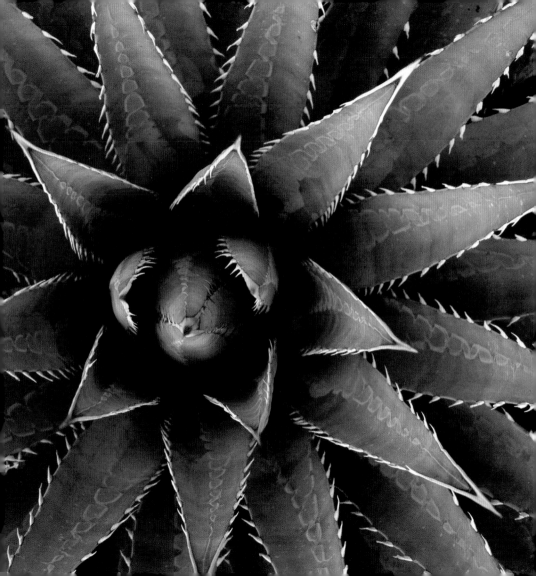

The whole gorge for miles lay beneath us and it was by far the most awfully grand and impressive scene that I have ever yet seen.

–Thomas Moran, 1873

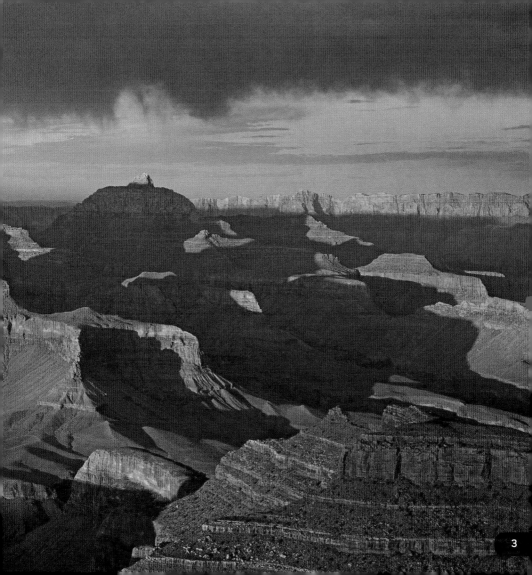

There are places in the world that you see with your eyes and there are those you see with your heart. The Colorado River and Grand Canyon are that way for me. . . . We are reminded of our own humanity on the river. And we are restored.–CHRISTA SADLER, 1998

4

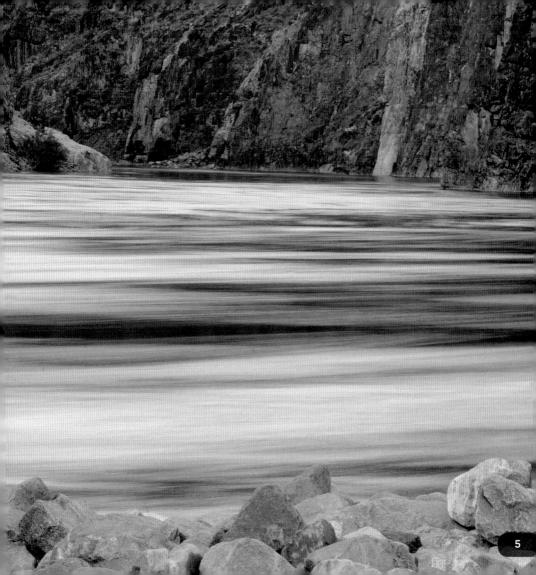

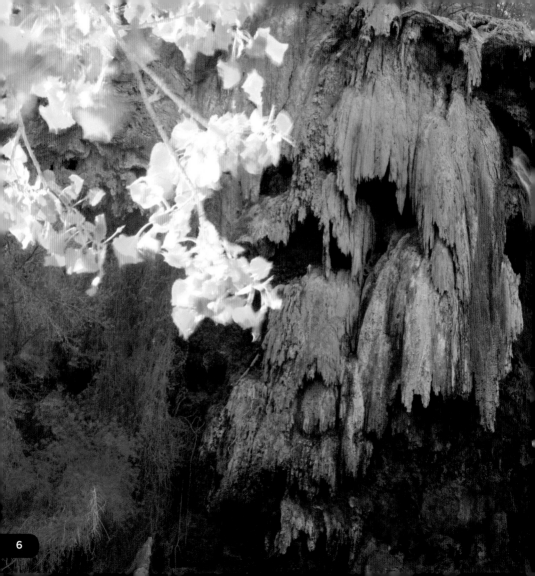

It is remarkable how soon the world fades into complete oblivion and this rock-bound solitude is the only existence which seems real. . . . One could forget a great sorrow here within a month.–WINIFRED HAWKRIDGE DIXON, 1924

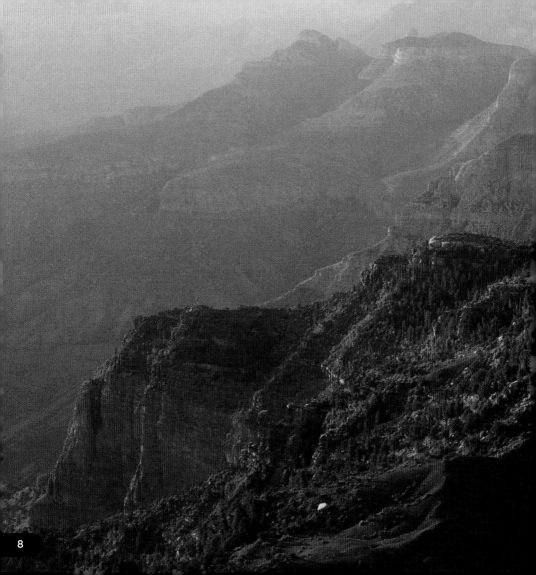

The glories and the beauties of form, color and sound
unite in the Grand Canyon.–JOHN WESLEY POWELL, 1895

It is never the same, even
from day to day, or even
from hour to hour. . . .
Every passing cloud, every
change in the position of
the sun, recasts the whole.
—Clarence E. Dutton, 1885

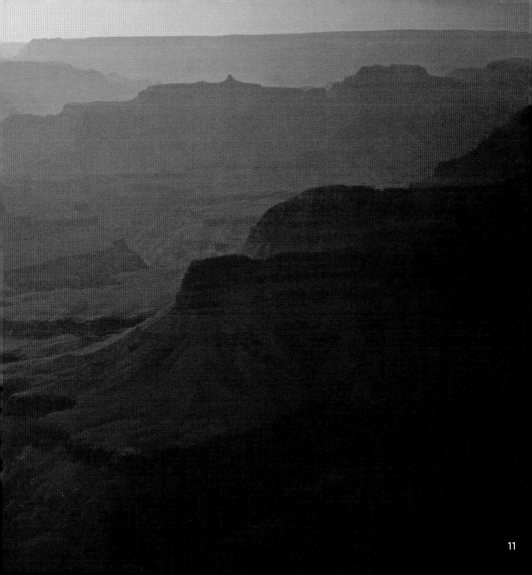

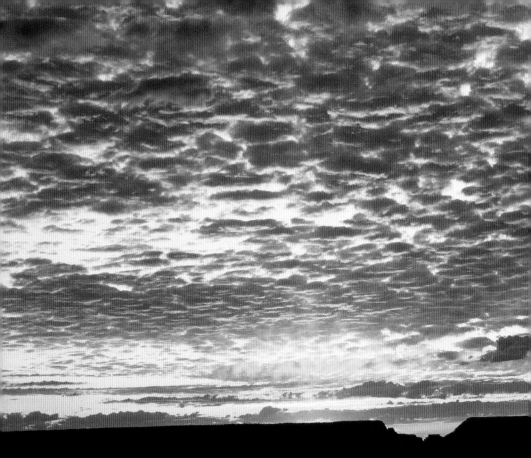

The Grand Canyon of Arizona . . . is wild and sublime, a thing
of wonder, of mystery; beyond all else a place to grip the heart
of a man, to unleash his daring spirit —ZANE GREY, 1922

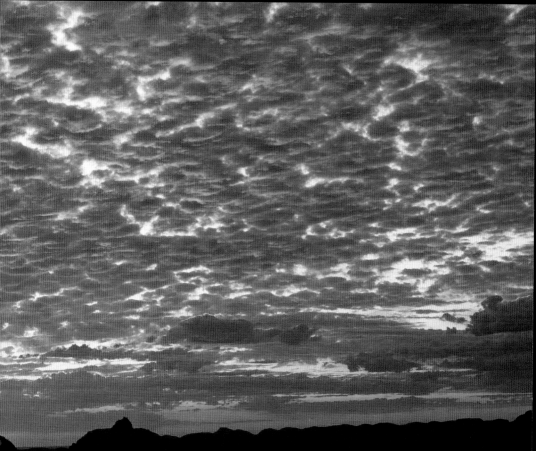

The Colorado was as incapable of serenity
or anger as the rocks of its Canyon walls.
. . . Still the illusion was tenacious that
the river had a will and character of its
own.–François Leydet, 1964

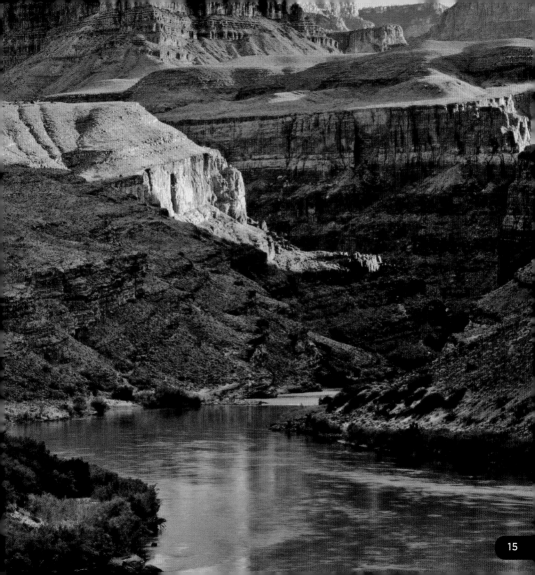

The finest workers in stone are not copper or stone tools, but the gentle touches of air and water working at their leisure with a liberal allowance of time.—HENRY DAVID THOREAU, 1873

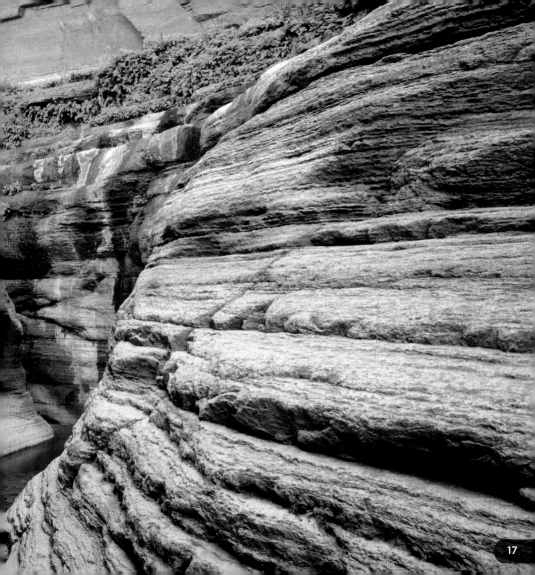

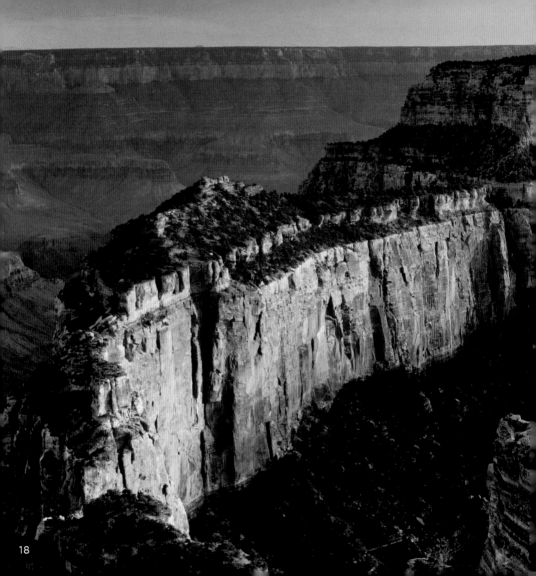

The Grand Canyon is carven deep by the master hand; it is the gulf of silence, widened in the desert; it is all time inscribing the naked rock; it is the book of earth.–DONALD CULROSS PEATTIE, 1941

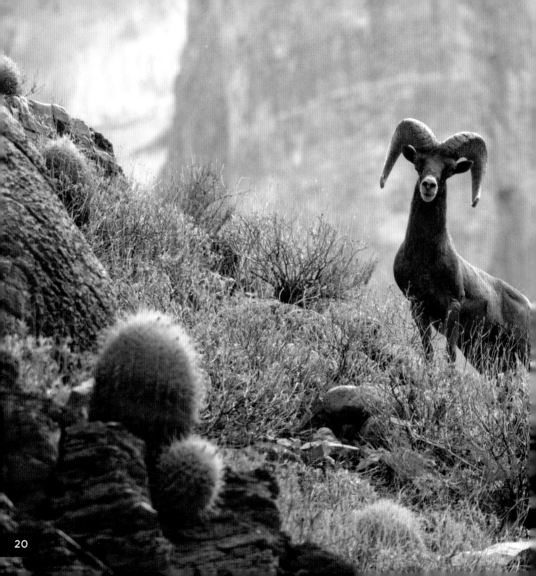

In the end we will conserve only what we love. We will love only what we understand. We will understand only what we have been taught.—Baba Dioum, 1968

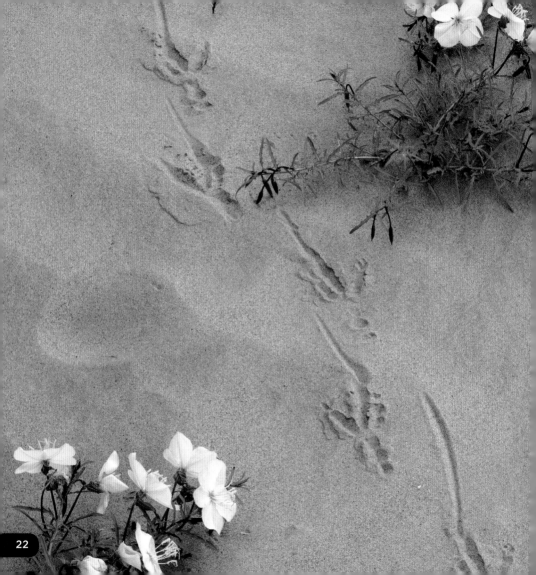

When your spirit cries for peace, come to a world of canyons deep in an old land; feel the exultation of high plateaus, the strength of moving waters, the simplicity of sand and grass, and the silence of growth.–AUGUST FRUGÉ, 1977

I saw the Grand Canyon as one hears an exquisite poem, a soft strain of music on violin, cello or oboe, or sung by the human voice. . . . It affected one as beautiful flowers do, as the blessing of an old man or woman, as the half unconscious caress of a sleepy child whom you love.—GEORGE WHARTON JAMES, 1910

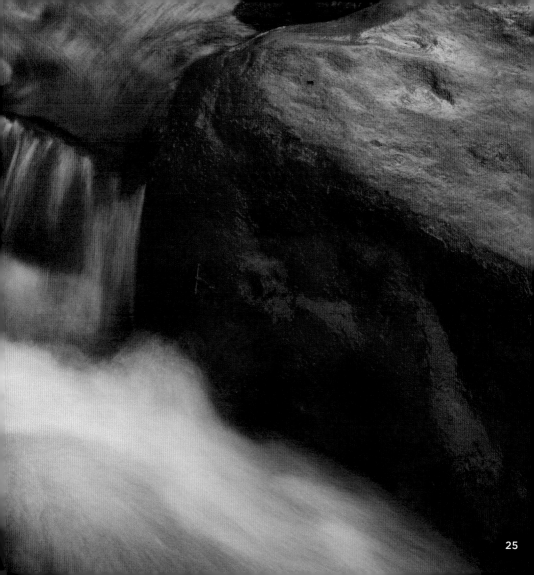

To remember that [the Grand Canyon] is still there lifts up the heart.
—J. B. PRIESTLEY, 1935

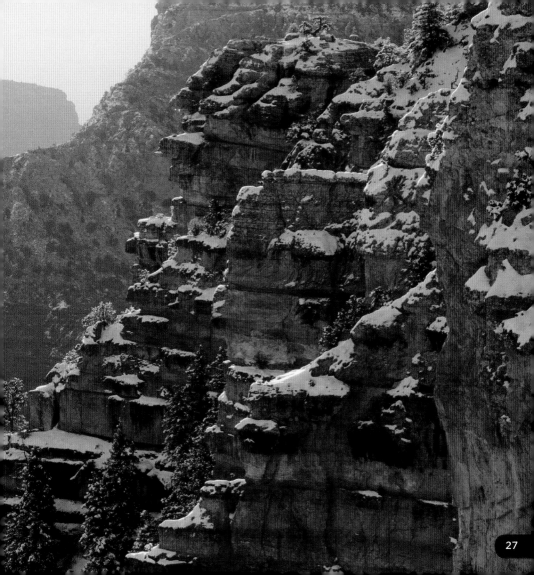

The sharply defined
colours of the different
layers of rock had
merged and softened,
as the sun dropped
from sight; purple
shadows crept into
the cavernous depths,
while shafts of gold
shot to the very tiptop
of the peaks, or threw
their shadows like
silhouettes on the
wall beyond. Then the
scene shifted again.–
ELLSWORTH KOLB, 1914

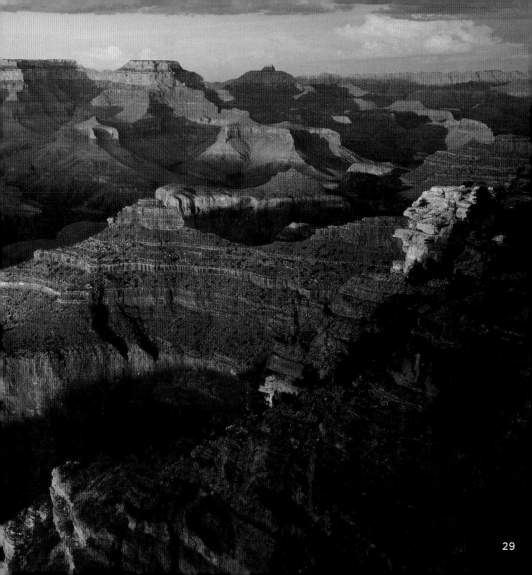

There is something about the desert. . . . This quality of strangeness . . . remains undiminished. Transparent and intangible as sunlight, yet always and everywhere present, it lures a man on and on, from the red-walled canyons to the smoke-blue ranges beyond –EDWARD ABBEY, 1968

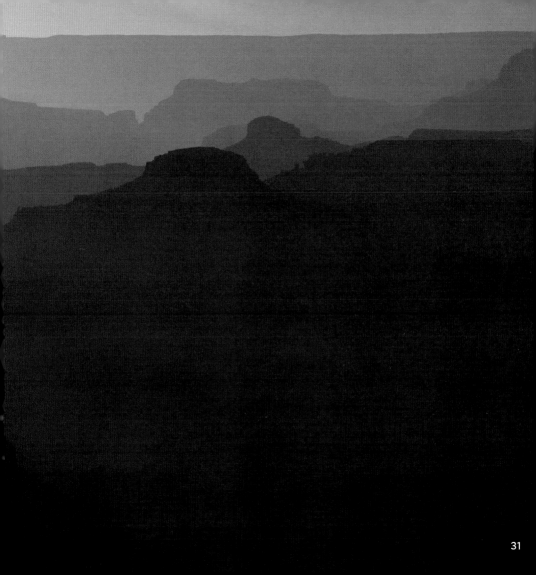

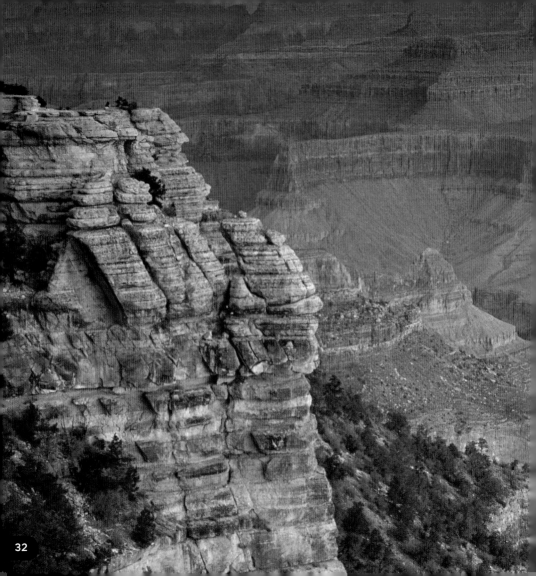

Our kinship with Earth must be maintained; otherwise, we will find ourselves trapped in the center of our own paved-over souls with no way out.–Terry Tempest Williams, 2008

The spectacle is so symmetrical, and so completely excludes the outside world and its accustomed standards, it is with difficulty one can acquire any notion of its immensity.–C. A. HIGGINS, 1895

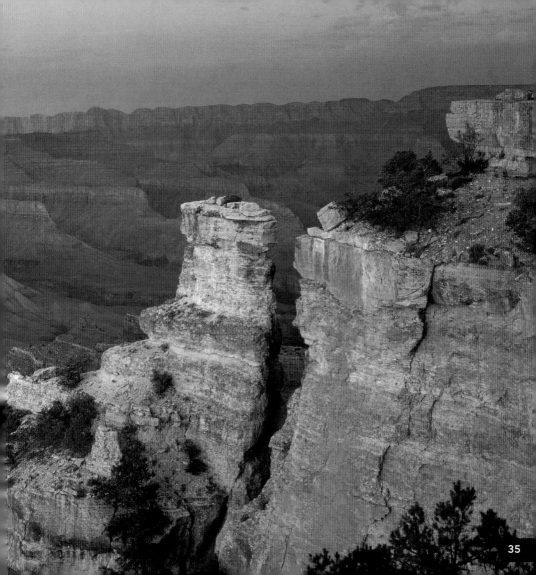

Remember what you have seen,
because everything forgotten
returns to the circling winds.
–NAVAJO WIND CHANT, DATE UNK.

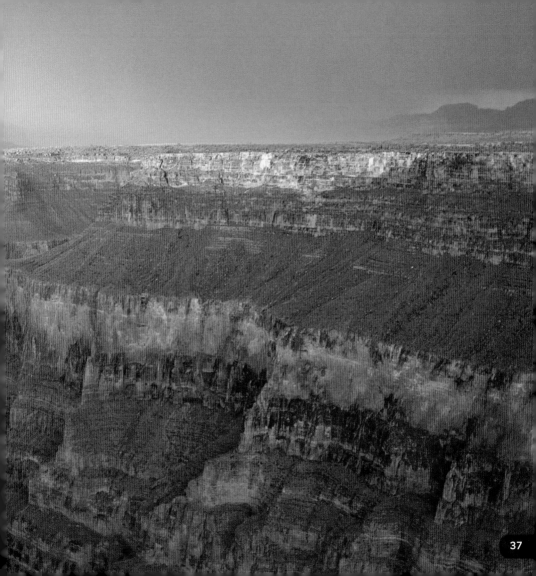

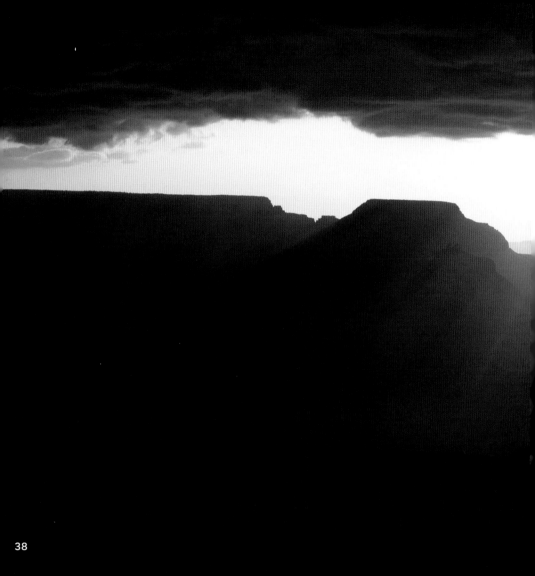

No matter how far you have wandered . . . the Grand Canyon of the Colorado, will seem . . . as unearthly in the color and grandeur and quantity of its architecture, as if you had found it after death, on some other star.—JOHN MUIR, 1898

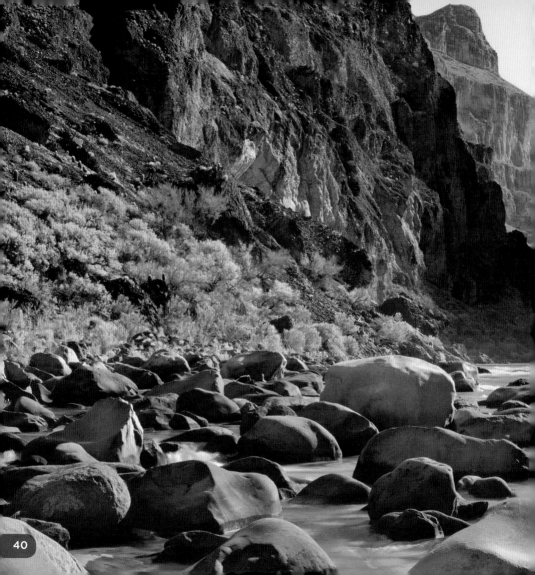

Leave it as it is. You cannot improve on it; not a bit. The ages have been at work on it, and man can only mar it . . . keep it for your children, your children's children and for all who come after you, as one of the great sights which every American, if he can travel at all, should see.—PRESIDENT THEODORE ROOSEVELT, 1903

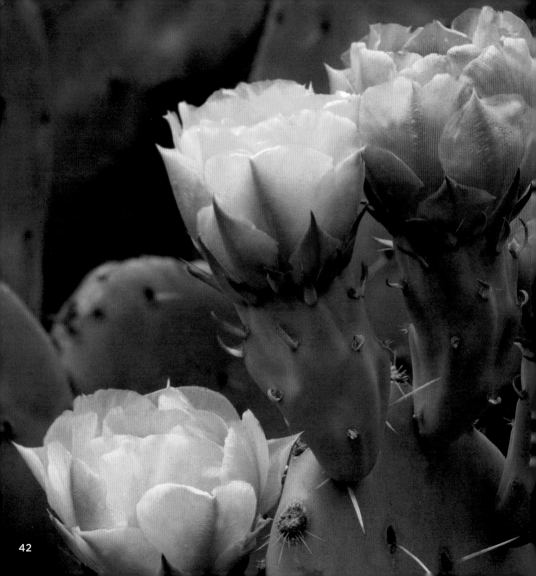

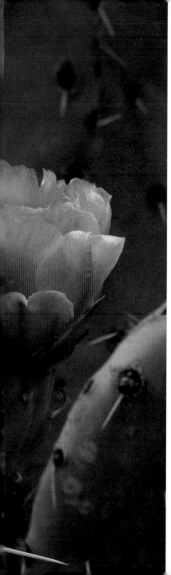

Photography Credits

Front cover: David Boswell
ii–iii: Dick Dietrich/Dietrich Leis Stock Photography
1: Fred Hirschmann
2–3: Mike Buchheit
4–5: Larry Ulrich
6–7: Kerrick James
8–9: Fred Hirschmann
10–11: Mike Buchheit
12–13: Dick Dietrich/Dietrich Leis Stock Photography
14–15: Tom Till
16–17: Larry Ulrich
18–19: Dick Dietrich/Dietrich Leis Stock Photography
20–21: Kerrick James
22–23: Larry Ulrich
24–25: Fred Hirschmann
26–27: George H. H. Huey
28–29: Dick Dietrich/Dietrich Leis Stock Photography
30–31: Dick Dietrich/Dietrich Leis Stock Photography
32–33: Dennis Flaherty
34–35: Dick Dietrich/Dietrich Leis Stock Photography
36–37: Mike Buchheit
38–39: Dick Dietrich/Dietrich Leis Stock Photography
40–41: Larry Ulrich
42–43: Larry Ulrich
44: Kerrick James

In wildness is the preservation of the world.–HENRY DAVID THOREAU, 1862